Still Blue

Still Blue

New and Selected Poems

Elizabeth Goldring

BkMk Press
Kansas City, Missouri

Copyright © 2023 by Elizabeth Goldring

BkMk Press, Inc.
bkmkpress.org
Fine books since 1971

Book and cover design: Cynthia Beard
Printed by Puritan Press, Hollis, NH

Many of the poems in this book previously appeared in the following:
Laser Treatment. Boston: Blue Giant Press, 1983.
Without Warning. Kansas City, Missouri: BkMk Press & Helicon Nine Editions, 1995.
eye: poems & retina prints. Kansas City, Missouri: BkMk Press, 2002.
The Light Silo/Das Licht Solo. Paris: Delight Edition, 2014.

-

Names: Goldring, Elizabeth, author.
Title: Still Blue: New and Selected Poems and Retina Prints / Elizabeth Goldring.
Description: Kansas City, Missouri: BkMk Press, [2023] | Summary: "*Still Blue* forms a collection from Goldring's work across the decades in poetry and images. As a poet and visual artist who is legally blind, Goldring explores different ways of seeing through the concision of poetic syntax, through her innovative experiments with the scanning laser ophthalmoscope, and through poems that consider vision, its loss, disability more broadly, human mortality, natural beauty, and the poet's response to war. Poems are chiefly set in North America, especially New England and the Midwest, as well as Europe"-- Provided by publisher.
Identifiers: LCCN 2022048108 | ISBN 9781943491384 (trade paperback)
Subjects: LCGFT: Poetry.
Classification: LCC PS3557.O3846 S75 2023 | DDC 811/.54--dc23/eng/20221121
LC record available at https://lccn.loc.gov/2022048108

Cover: *Still Blue*
Elizabeth Goldring, Hüttenstrasse, Düsseldorf, 2018
Photo: Elizabeth Hua Olson

DEDICATION

Still Blue is a tale of presence and loss. It is in a sense an homage to my late husband, the artist Otto Piene. It is also an homage to my friend and editor over a lifetime, Dan Jaffe.

Dan and I shared animated discussions about each poem in *Still Blue*. His insights as to what I was saying often extended my own perception of what I had actually said. At times this caused me to alter words or try to hide inside them. However, in a game of hide and seek, Dan usually found me out. He said he delighted in how I forced him to see in new ways as he grappled with descriptions of my visual perception. Even after his memory began to age, Dan remained alert to the nuances of words and rhythms. It was wonderful and edifying to speak poetry with him. Ours was, to my mind, a perfect correspondence between editor and writer . . . and still I hear his words although I miss the closeness of his voice.

CONTENTS

Dedication	5
The Retina Prints—An Explanatory Note	11

I

Dandelion Puffs	15
Paris–New York	16
We in America Know There's Always Choice	17
Cat and Mouse	19
Going Blind	20
Nearly Expired	21
Early Morning Provence	22
Swimming	23
Powerless in Cologne	24
Gozo	25
The Pope	28
Landowner	30
Winter Wedding	31

RETINA PRINTS

Night Blooming Cereus – Night, 2006	32
Night Blooming Cereus – Day, 2006	33
Old Woman, 2007	34
Face of the Dragonfly, 2001	35

II

White Iris for Ingie	39
For Joann	40
Night Blooming Cereus	41
Memorial Day	42
Birth Days	43
Shadows	44
My 95 Year Old Mother	45
The Gardener	46
X-Ray	47

War Letters	48
The Day My Father Died	49
On Leaving	50
The Artist's Studio	51
Six Weeks After You Died	52
Departure	54

RETINA PRINTS

Blue Light, 2001	55
Descent, 2001	56
Prague, 2003	57
Murano Virgin on Goldring's Retina, 2002	58

III

Summer's See-Saw	61
The Yellow Swimsuit	62
My Hands Cannot Perform the Tasks of Hands	63
My Lover	64
Winter	65
The Black Shape	66
Morning Light	68
Weekend Snow	69
Just Blow It Up	70
View	71

RETINA PRINTS

Frog Pond, 1999	72
Wandering Monk, Kyoto, on Ananda's Retina, 2002	73
Cracked Glass, 2007	74
Bit, 1997	75

IV

Panos	79
Your Song	80
The Word Surgeon	81
Phaeton	82
Prime Time T.V.	83
Rose	84

On Writing	85
Diary Excerpts, Gordes	86
Blinded in Byzantium	87
Lingual Decrepitude	89

RETINA PRINTS

Snow, 1995	90
Logos, 2001	91
Cry, 1998	92
Turn, 2001	93

V Poems from *Laser Treatment*

Nightletter	97
Fiesta	98
Woman	99
Skin	100
Blue Chair	102
Jessica's Nightmare	103
The Night Machine	104
High Noon	105
Disappearance	106
Laser Treatment	107
Blind	108

RETINA PRINTS

Swim, 1999	109
Door on Sabrina's Retina, 1998	110
Horseplay III, 2004	111
Glowing Retina, 2001	112

VI Poems from *Without Warning*

Aztec Moon	115
Tall Buildings	116
Souvenir	117
Charlotte Moorman Trilogy	118
Blue Haven	122
Socks	123
The Ashford Motel	124

Farm Stories	125
Gedächtniskirche	126
Sunflowers	127
Yoyo	128
Post Op	129
Morning Glory	130
Stained Glass	131
The Electronics of Blindness	132
She Construction	133
I Need a Metaphor	134

RETINA PRINTS

Lunar Landing, 2003	135
Cat's Eye Nebula on Ananda's Retina, 2003	136
Twin-Eyed Galaxy, 2004	137
Goethe's Sun on Goldring's Retina, 2003	138

VII Poems from *eye: poems & retina prints*

On Returning to Taroudant	141
Lavender	142
Driving Down to Nice	143
Dubrovnik, 1996	144
Wild Flowers	145
Going Home	146
The Casket Shop	148
Eros Ambulance Service	149
Harry	150
A Poet's Bath	151
Trainspotting	152
Reconstructing Dan	153
No Smoking Please	154

RETINA PRINTS

Eye to Eye (Astronaut), 2003	156
Goldring's Dynamic Splint on Her Retina, 2000	157
Cavity, 2005	158
Waves, 2005	159

VIII Poems from *The Light Silo/Das Licht Solo*

Echoes of Fire	163
The March Bell	165
The Light Silo	166
Cobwebs	168
The Scarf Dancers	169
Antarctica	171
Frog	172
Ornithology	173
The Last Time	174
In Berlin	175
Ceely (a.k.a. Maude)	177

RETINA PRINTS

Eye to Eye (Elizabeth Goldring on Otto Piene's Retina), 1999	179
Nebraska on Goldring's Retina, 2001	180
Hornet's Nest, 2002	181
Dome, 2007	182

Biography 184

THE RETINA PRINTS: An Explanatory Note

For me the Retina Prints are visual poems. Each retina "animated" by the octopus-like tendrils of the optic nerve is as individual as a thumb print. The words and images projected onto my damaged retinas with the Scanning Laser Ophthalmoscope (SLO), retain an indelible "after-image" quality that I celebrate with the Retina Prints. They are traces of a laborious experience of seeing—memories woven of images and words "sitting on my retina."

The Retina Prints are based on analog video captures of the retina (the back of the eye) looking at visual information – faces, words, landscapes, etc. The SLO is the diagnostic medical instrument that scans visual information onto the retina. It also records the retina in action. My images of the "looking retina" are digitized, "painted" in Photoshop and eventually printed on large-format printers.

My impulse to make Retina Prints and to use the SLO as a "seeing machine" was precipitated by a remarkable experience several months after I became blind, with only light and shadow perception in both eyes. I was given a test to determine the degree of remaining retina function. With the SLO, "stick figure" images were projected onto selected areas of my retinas. When I discovered that I could actually see some of the test pictures I asked if I could try a word—the word *sun*. I could see that, too. It was the first word I had been able to read for many months.

Since that day I have experimented with the SLO, using it as a "seeing machine" for my right eye which still has residual retina function but no useful vision. Although I am legally blind, I have intermittent sight in my left eye. In collaboration with the SLO inventor Rob Webb, and physicians, scientists, engineers, artists and students at MIT and Harvard, I have created visual experiences and poetry for people with low vision or no sight at all. To avoid confusion and frustrating "white noise," I believe that visual communication for people with impaired sight could rely on the same principles of economy and intensity that guide my poems – saying much with little.

My fascination with the technology lies in being able to transport my art and poetry to places where it might otherwise not be seen or received. Several years ago I wrote, "my dream is one day people who are blind will be able to enjoy internet access to public buildings, outer space, faces of loved ones as well as the words and glyphs of poetry." In 1996, at MIT we hooked up an SLO to the internet and the world of virtual reality. With MIT students, I made a series of portable seeing machine camera prototypes which I could use to photograph scenes from nature as one basis for my retina prints.

Elizabeth Goldring

I

Dandelion Puffs

Yellow fields

 life in a knot
Daddylonglegs
 pulls
 you
 down

till something cuts the cord.

A puff
 a thought
flies out.

Paris–New York

She went to meet him.
 At a café near Hôtel de Ville
he wished her success.

 She tripped.
The bag with the absinthe
 came down hard,
ruining her drawings and pastels.

Back in Brooklyn
there's a cockroach.
 She says
he has a face
 so big
she hears him
 chewing.

We in America Know There's Always Choice

Over three days we dropped nine hundred bombs on a terrified town.

 The oxygen in the air
 GONE.

Half a world away
I was screaming
 pulled from a womb
like Caesar.

Dresden
 on fire,
the river too.

You couldn't breathe.
 A m n e s i a
 only way to get out alive.

An old lady screams obscenities
to a courtyard in Düsseldorf.
 No one quiets her.

The church bell
smashed to the ground
 cracks radiating.

I see the bell on the floor of his retina.
 The bell of his eye,
 his optic nerve.
 Burning
 flying
 falling
people
 exploding

```
like the bell
      on the floor
              of the cathedral
      in Cologne.
```

Cat and Mouse

White cat's caught a mouse cry
wraps his paws around her throat
shrouds her death
in wedding clothes.

Going Blind

Once again
 I cannot see
 the elevator buttons,
cannot feel
 the raised seven,
cannot recall
 the sequence
 of my dreams.

Nearly Expired

It's the first year he didn't set
my birthday table,

no flowers except
nearly expired lilies
 I bought two weeks ago.

No candles,

no reminders of
 how old
we have become.

Early Morning Provence

Geranium tea
 good for digestion,
a single wasp
 inhaling
 ecstasy.

Fig jam.

 After love making
 the sweetest birdsong,
 clairvoyant
 si voyant.
How tender we were

 until
I changed

 you said,
and the problem,

my reaction time.

Swimming

A pale woman
 dark hair,
 dark eyes
 s w i m m i n g.

At the pool's edge
 her lover kneels.
She nods but
does not slow her pace.

For days
 she watched him
 come and go.

Today she smiled
 slightly.

Today
 we drank *jus d'apricot*
 at the outdoor café
in Gordes.

The light
 barely ochre,
 barely pink.

Powerless in Cologne

Lighted spires go out.

Counting fingers for houses
we arrive at our friends' electric gate.
 Chairs stacked
 we climb over.

 Later

an architect springs the lock

 with his knife.

A drink of blue moon
 blood black
in the glass,

sparks fly from the belly
 of a candle.

Heavy footed men
 stomp by
looking for the problem.

 Someone jibes,

"Power comes from Africa."

Otto and Franz

 speak of Nazi blackouts,

 forbidden lamps.

Gozo

. . . even a deathless god who came upon that place would gaze in wonder, heart entranced with pleasure.

Homer, *The Odyssey, V:71-82*, (R. Fagles' translation)

I.

We pooled our coins,
flew to Gozo
where news arrives
a day late
and the population's counted
in families
(40 to 60 per village, we're told).

The official language is English.
But real talk's ripe with
guttural "g's"
Hebraic, Italian and Arab roots.

A Gozitan woman
speaks out against Bush
for killing Iraqi mothers and children.
 "What will happen to him?"
 she wants to know.

It's Calypso's land
to be sure.
Raging storms, winds, hail,
 holes in sky,
 blustery shadows.

Past the quarry
a condemned farmhouse.
Past the fields of hops
and yellow daisies

 we walk as far as
 Santa Lucia.

Balanced architecture:

 right-angles,

 cubes, arches,

no mistakes.

2.

beets and boiling lobsters,

 all things becoming

 red . . .

As we approach Dwejra Bay
we walk over trilobites
 and skeletons,
crushing shells to shards
 so fine
 they may break
Calypso's
 infinite
 window.

So Odysseus came by sea.
 Pulled to her azure frame
Odysseus,
 borne inside winds and rain
washed ashore.

Panhellenic clouds

 make all weather
 in the blink of her eye.

Calypso emerges to dance on the wind's ferry.
 The weather
 a scarf she twirls above her.

Thistles sparkle,
 smashed disks,
 fossil suns.

Her opening
 smooth as calamari,
 her beckoning glove
taut with *acceuil*.

Webbed crevasses spill
 sweet and sour blood oranges,
 pomegranate,
beets and boiling lobsters,

 all
 becoming
 Red.

Calypso's mirth gurgles up
and the island women fill their jars,
weave fresh garlands for Odysseus.

The Pope

 New York City
nine, twenty-eight, fifteen

A sash of white
 light
proffers sky
 a ladder
linking earth and
 See.

 A l o n e
on the jetway

his satchel
clutching his left
 hand,

he stumbles
 falters
almost falls

 so tired—
attaching ropes to
 his blimp of a
 sky school

unfurling ladders
for all of us
 to climb—

the rest,

 trumpeting,
 terrifying,
 even

 trajectories
 ↑ up
 down ↓

ladders ↑↓

Landowner

Don't know how to make the tractor run
or where the weeds get composted.
My land and house
are eating me
sure as deadly nightshade,
strangling me
as I try to free
a rhododendron
from the one
who is choking.

Winter Wedding

 Sea gulls
their cries
 holding long
 on frigid air.

The breaking points of waves.

Pounding noises
 swelling into
light sweeping
 surfaces
 saying
 I do.

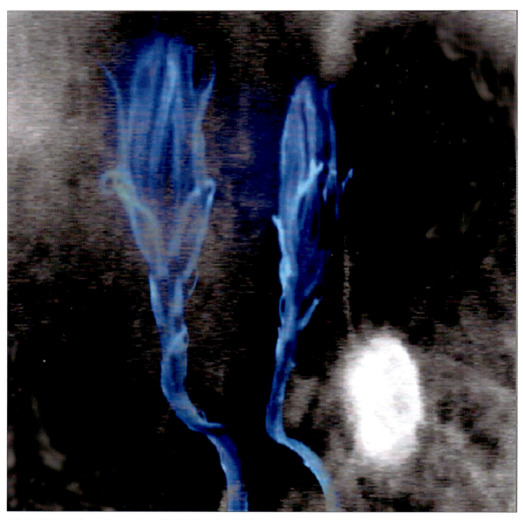
Night Blooming Cereus – Night, Retina Print, 2006.

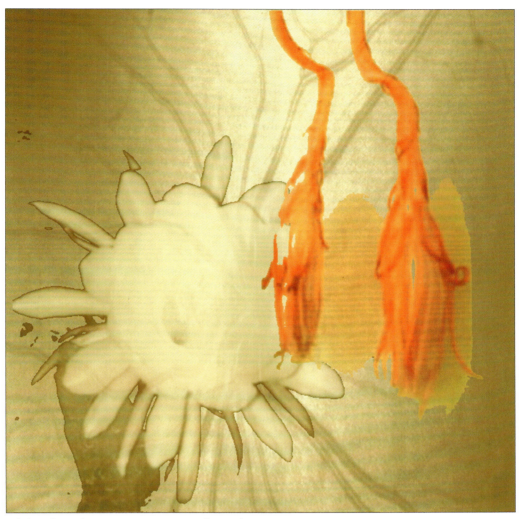
Night Blooming Cereus – Day, **Retina Print, 2006.**

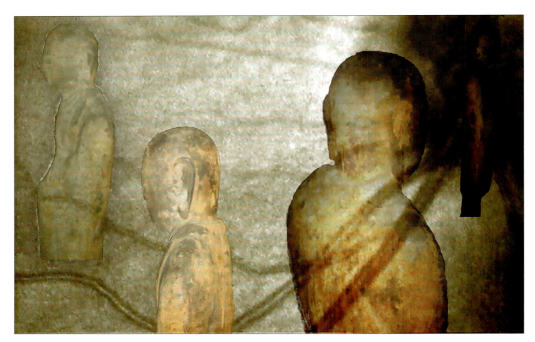

Old Woman, Retina Print, 2007.

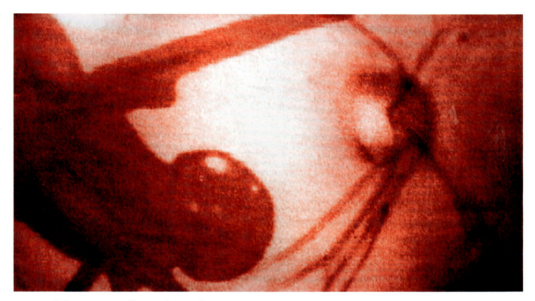

Face of the Dragonfly, **Retina Print, 2001.**

II

White Iris for Ingie

The Iris of the Eye is a Greek Rainbow

Her May skirts
 splash white
onto today's canvas.

(I miss her dream of carrying blueberries
 to South Africa.)

Her legacy
 opaque
 as it is white
 except
 at the edge
 of one petal

where colors gather,
 into a rainbow.

For Joann

In the upper field
a deer
hit by sunlight.

In the lower field
dark spots
are deer too.

In Dan's voice
your wings,
your fingers,
your spreading silence.

Night Blooming Cereus

The spent plant sits
 atop a piano,

 remembering

night:

 smells of cardamom
laced with madness,

a pink net of

 vibrating petals.

 Wrapped lady,

opens raw

 breaking into fresh

 odors.

Memorial Day

Red disk on a spider stem
 opens a yellow eye
 smiling almost
 like a pansy
 but not
so much face.

One blooming poppy
A blood stain in shadow.

Somewhere
 a whole field of
red poppies

sentinels
 under cypress.

Poppies in wheelchairs,
 on crutches,

 trying out

for the American Red Cross
 poster project.

Birth Days:
2/13/1945
9/11/2001

They burn,

become
 ground
we
 will rebuild.

Infants
 born those days

 cannot hear

 cannot feel

 cannot think
to know.

Nor,

will I remember my own birth day,

 the day
we bombed Dresden.

Shadows

Today I picked daffodils
today I swam the shadows:
the shadows of ripples and edges
the shadows of leafless branches
the shadows of two chaise lounges
kneeling side by side in the grass
the shadows of things mended and things destroyed
the shadow of the black bear,
the silver fox,
the bobcat sneaking close,
your shadow
as you pass
in the shape of a red-tailed hawk.

My 95 Year Old Mother

My mother is not doing well.
Again her gown is soaked in urine.
Again she says she feels poorly,
no energy.
She doesn't want to eat,
drinks Gatorade instead.
Again she doesn't remember
when I will come to visit,
or if I've been there recently.
The doctors say
nothing's wrong.
Maybe tomorrow
they'll know more.

The Gardener

For years
he's been applying
for a purple heart.

First his records burned,
then the bureau of records
back in St. Louis
went up in flames.

Now he's out there
sawing off flowers,
broccoli,
birdsongs,
anything
he can mow down.

X-Ray

The X-ray technician says
 I wore the wrong clothes.

How could a black dress
 on this black day
 be wrong?

Something jugular's aloft.
Yesterday's thought train
 held up by a lunatic.

Where have all the artists gone?

War Letters

 I saw the basement
 in his eyes.

His mother
 not a loving woman.

 Sometimes

 my mother not
 a loving woman.

His tortured face
 my face
 no Jamaican lullabies.

 What happened
 to make him so afraid
of animals?

Their war letters
speak
 only love.

The Day My Father Died

Once,
in the morning
his eyes
flew open.

His brain undone
pure feeling
swam between us.

At sunset
he became tomorrow's secret.

On Leaving

You crushed the closed hearts of clams
 under your shoes,

carried the ocean's rhythms away.

At my feet
 a birdhead.

Its bony spine ends
in a feather.

The Artist's Studio

A lighted house
 across the night and
 rhythms of sleep,

 across
 stones

 up steps.

He is working late.

As I pull on my coat,
 the light goes out.

I listen
until I hear his cane
 at our door.

Six Weeks After You Died

Small birds and not too many.
Pine cones dropping.

The mystery's
 how
 I got here.

Remembering Maine
 another year.
The knotted, lichened
pine trunks twisted
 yes
but reaching out.

The boat with
 rigid masts
 is in the bay
interrupted by yachts.

The mystery's how I got here.

The boat is moving now
 away from land.

I climbed a dune
repeating mantra after mantra.

A cell phone rang.
The one I want to call,
 will not.

After all those years
 I'm left
 one kiss.

(Back home, a tree explodes
 into a thousand suns.)

Waves come churning
 in a gallop
 drunken at my
 feet and dunes
spill
 onto
 parking lots.

Departure

I think of
 my mother who
lies in the hospital
 bruised and swollen arms
 a failing heart.

The Provincetown ferry's
 speeding
 away.

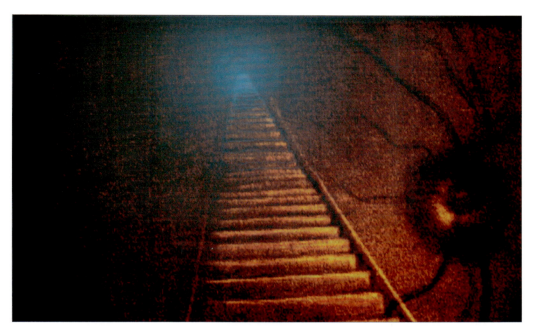
Blue Light, **Retina Print, 2001.**

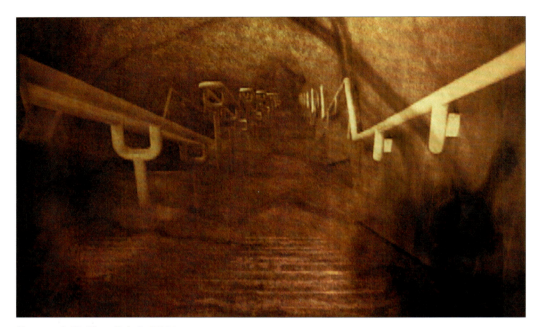

Descent, **Retina Print, 2001.**

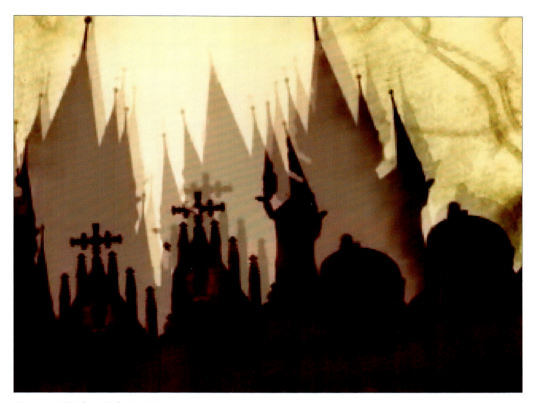

Prague, **Retina Print, 2003.**

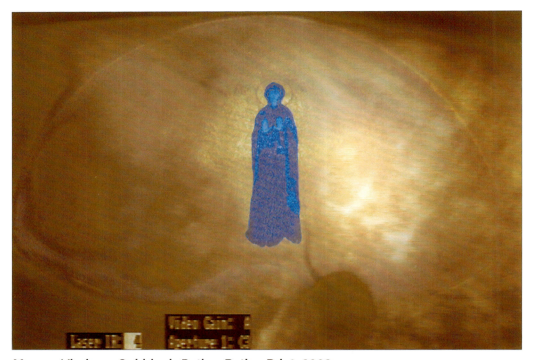

Murano Virgin on Goldring's Retina, **Retina Print, 2002.**

III

Summer's See-Saw

A plump Rose of Sharon
amidst drying phlox,
bitter lettuce,
dill gone to seed
cilantro turning to coriander.
Hard little peaches
still to ripen,
pears, too.
And winter already
rattling my bones.

The Yellow Swimsuit

In the locker room a woman
fingers her swim suit,
can't get it
over her legs.
She becomes cold,
just wants to lie on the bench,
sleep.

Every afternoon it's like this:
the tired feeling,
eyes watching,
her foot
attached to the leg
of the one
looking.

My Hands Cannot Perform the Tasks of Hands

Two operations,
 hot wax,
 a hand contraption
 like a crane
couldn't keep my hands
 from becoming
my father's hands.

I noticed the bumps
as I drove across the Mass Ave bridge
 from Cambridge to Boston
before I got divorced.

I thought of cancers,
 punishment for my
 life out of control.
Long fingers
 stretched full,
my hands
still beautiful then.

My father's hands
 unable to clap,
 flatten against a table,
 unable even
to peck a keyboard.

As he lay dying
I forgot to look at his hands.

My Lover

 Comme d'habitude
the pimple
 at the tip
 of his nose
 bloomed
 the day before.
 Popped
the day after.

Winter

I breathe deep clean dreams,
 a runner's high.

Sheets of bright white
 fog
 dust my eyes.

 I cannot
 focus.

Winter
 borrows the force of blindness.

The Black Shape

In Puerto Rico,
no one wears glasses.

Black shape
winged on top
rises
nauseous close
out of ocean's night.

At sky's horizon
it's lighter.

Inside the shape,
space,
stars,
stiffen,

subtend
sub, sub, sub
sub t e n d.

I am not asleep.
I cannot shift it out of sight.

My chest pounding,
the tides,
I try to s y n c h them.

Lights out

N O
O N.

Why now?

Who goes
where?

Robot sentries
pull out black revolvers,
pour yellow rays
into the night.

I am blind.
I cannot sleep
to dream.

Morning Light

I write words I can't see
pen invisible ink from black markers.

 Light
 creeps in

through broken balustrades.

 A wiped sun
 burns holes
in paper.

Weekend Snow

Fence posts lean on split rails.
 Tumbleweed's
 caught at the neck.

Sugar-coated fields,
 dead birds
 and cats.

In a crack of light
 shadows of a failing philodendron.
Angels lift it up again
 N o o x y g e n
 no chance even
to buy a tank for the weekend.

Legs split into broken rails.

 Life's breath
 short in my mouth
January seemed the longest month
 with February
 only 8 days old.

Just Blow It Up

"Just blow it up
you'll see it all."

 voices, sounds
words
 life's alliteration
breaking into shapes
 landscapes
 the flow of alphabet and space
 and the spaces
 in between.

An automobile accident
in the Vienna woods
shattered our windshield,
ruined my eyes.

"Writers don't need to see,"
 the Austrian judge proclaimed,
 my insurance claim
 denied.

We have all the answers
 at our fingertips
but we have
 no fingers

 and the heart's
 a numb thumb.

View

From this prison
 my eye scans
 a pillow,
 a book,
a pinch of paint

seeing
 hard to fake, forge
anticipate.

 Tobago

girls dancing
 au bord de la mer.

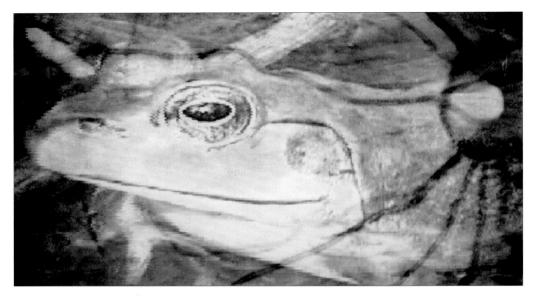

Frog Pond, **Retina Print, 1999.**

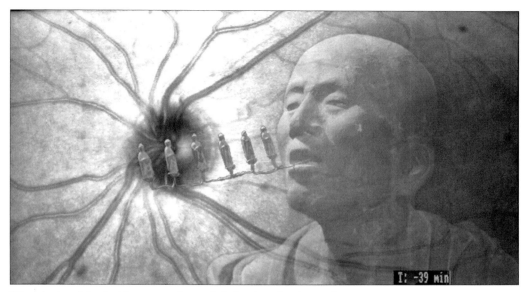
Wandering Monk, Kyoto, on Ananda's Retina, Retina Print, 2002.

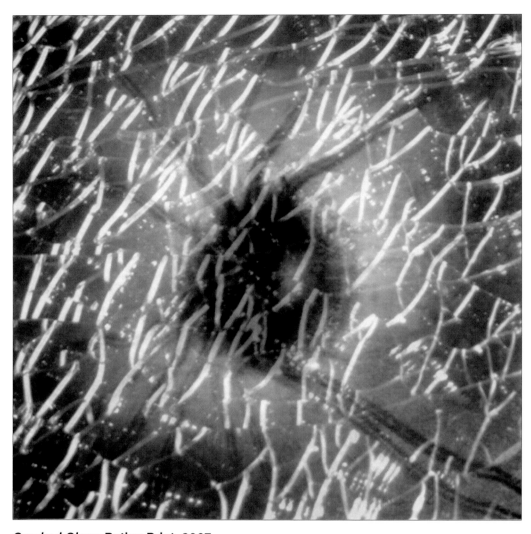
Cracked Glass, Retina Print, 2007.

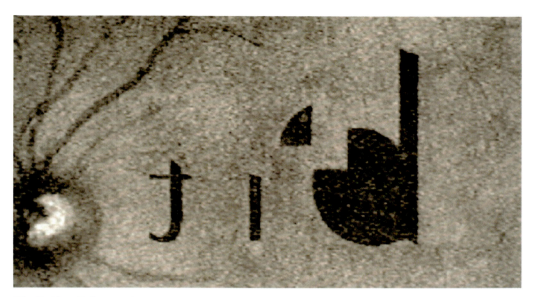

Bit, Retina Print, 1997.

IV

Panos

The notebook
 gift of a poet
is Greek.
 I miss him
when I think of Athens
 and his corner window
looking out on the Acropolis.

I remember the Elysian Fields,
that day we walked through the cemetery and
 you read me
epitaphs
 old
as language.

Your Song

I'm a turntable
 spinning
not as fast
 or as smooth
as your voice singing
 not as fast
 or smooth
as your song.

The Word Surgeon

Words
 caught in a womb
 no labor will push

 silent,
consummate there
until Caesar
 dislodges
one lost cry.

The stillborn soul
 cries out

 a single breath
on the surgeon's blade.

 Through a rush of dry tears
fall colors and flags,
 fluttering lights
expecting life

 turn
 cold

the unspeakable c o l d

 Eskimos have no words for.

Phaeton

He drove his father's chariot
 at the sun,
turned his sisters
 into trees.
 Their bark skirts
became their last words.

Prime Time T.V.

 bo – tox,

 the
 war
 in
 Iraq

flicker with equal avidity.

No
end to their
on o ma to poe ia.

Rose

Petals curled

 like ocean's tightest breakers.

The rose opens a little
 more

shows just

 a little
 more
flesh.

On Writing

 These pages
written seven days ago
 rise
 like folded airplanes
 into words
fire flight
 your life.

Only the chants and
memoried lines of
Keats and Coleridge remain
 ice cubes
in this glass of single malt.

Diary Excerpts, Gordes

Intermittent rain.
 The birds are not disturbed.

Ancient ambulance
 slow flashing lights
 one door flung back
 as if delivering bread.

An alarm in the night
 no burglar.
Today, the fire alarm
 mais il n'y a pas de feu.

Alarms for no reason.

 Ah,
there's always
 a reason.

Blinded in Byzantium

Walking to dinner
that first night
you showed me a building
hidden
except for a blue line.

In a restaurant
crowded with cigars
your face dimmed,
flickered out.

Later at the hospital
a doctor
held up fingers
I could not count,
waved hands
I could not see.

Everywhere
hawkers
were swinging glass eyes,
dumbstruck,
you said,
when they saw I was blind.

I became their seer.
They offered me bargains.
I wasn't buying
just tasting
the pull of taffy
the crunch of aged nuts.

• •

Back from Byzantium,
I leaf through a guidebook
of the city I have not seen.
Here and there
a page
that I remember.

No,
something only I
can tell:
the cat
sliding onto our bed
to say good morning.
In her touch
her smile.

Lingual Decrepitude

 The shift from *Sie* to *Du*:

When did it occur?

 In the rain?

Was it loud or soft?

 With champagne?

Du, Dir, Deine, Dich
 Ich liebe Dich.

Two equals
 one plus one
minus two
 minus one.

In this case the shift
 from *Sie* to *Du*
coincided
 with a shift

 from *Du* to *Sie*

although

 In English

the only form
 available

is Y O U.

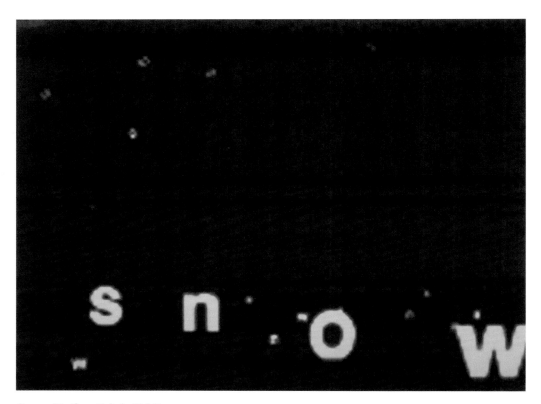

Snow, **Retina Print, 1995.**

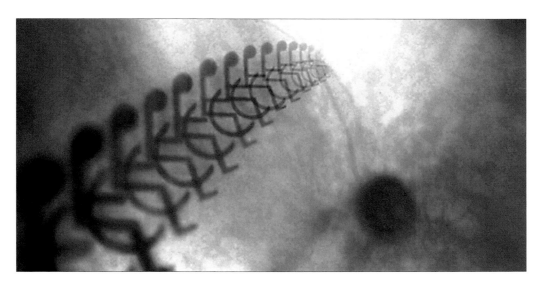

Logos, Retina Print, 2001.

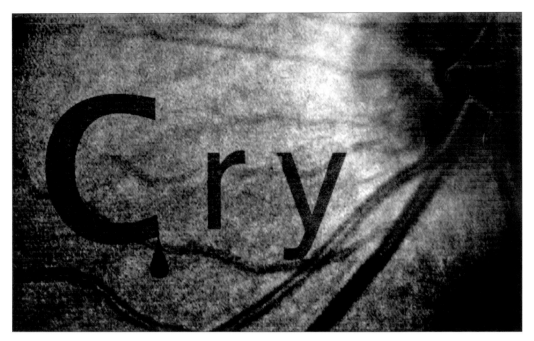

Cry, Retina Print, 1998.

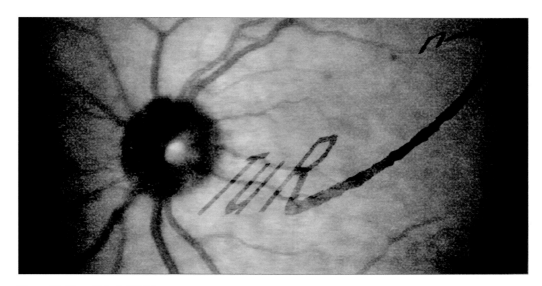

Turn, **Retina Print, 2001.**

V

Poems from *Laser Treatment*

Nightletter

In a char room
across the Atlantic
you are painting fire
into your paintings
I want to make something good
for you

Better tell me straight
how you cleared the lines
between art and anecdote
and why
you still let others
please you

Fiesta

Samuel's a bastard
fatter than a hair blower
he brings his carbon arc
will turn it on for a fee
to light up the sky
and the Niños Héroes
and the red palm fingers
of the big red flower
in the dark red sky

He says he likes the flower
straight up
he'll give us ten more minutes
for eighteen hundred pesos
he says it's very sexy
the big red spider
on the red, red town

Woman

Woman,
what does she know?

She firms a ladder
built of sleeping
giant clay
random flying first
lightly glowing
jumping salmon locks
it pales to smooth
cries out
grows soft
gathers fire cheeks
of ember

Woman,
what does she know?

Her pince-nez
magnifies a buttonhole

Skin

skin/
mediate
skin/
amplify
skin/
ignore
prostitute beats
pills, soapy
packages
low
pressure

can't you understand
it's not
the complaint that's
drowning me

break your phial
over me
your semen
fills my skin

food is bloody poison
only chance is
not to eat
to feed on
surfaces

stimulation
not for
whale
bone
braces

picket fences
girdled
mannequins

hair follicles'
real fodder
beetle casements
twirl the pelvic bustle

first
crocus
wilts
give it air
rubber
glove
drips
spring
treason

mud and rafters
bring
new worms
move
fourways
cut in half
quadruple eyes
squirt salt tears

glue
a
fresh
spring

Blue Chair

dusk lifts the blue chair
 I've come
 will not stay

too many owls

 stapled
 trapeze,
 light
 blinks

 unwinking
 shivering
 stare

chair's a wave
 beneath the wave
 a deep sea
 fishhead
 rises
swings a lantern

 chair's
 a blue swan
 flying

Jessica's Nightmare

She said a mouse hopped and
then a wolf came but
he didn't catch the
mouse who went too
high and the wolf tried
to hop as high as he
could but he couldn't
hop as high as the mouse and
the mouse said he would
call the king of lion because
he is tired of all this
shouting and fighting.

The Night Machine

lady mountain
woman bridge
cast-iron slots
hold her in
she plays
the night machine
stop crying
stop hoping
stop
hold it
all in

High Noon

he turned
down the road
in his humdrum jalopy
and rode to town
where he stopped
to untie his shoe
so he could watch
the cord ends dangle
as he walked back
toward the car

Disappearance

things
are disappearing
branches from trees
pieces of words
lines in faces

Laser Treatment

He is nailing light
into my eye
one nail at a time
219
says I'm doing fine

He etches an eye
on my eye:

eclipses blisters
sun spots grey
suns spiders

cobblers
jewelers
thieves
go blind

eye's a navel

in Guadalajara
boulevards are
strings on a package

Blind

my eyes are
burdens to
you now

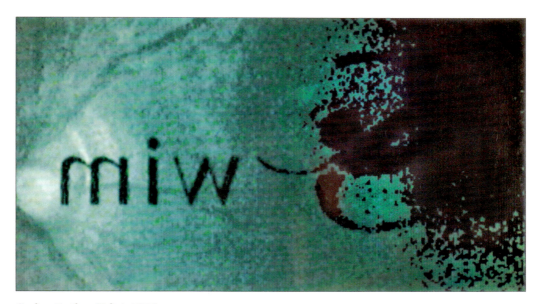
Swim, Retina Print, 1999.

Door on Sabrina's Retina, **Retina Print, 1998.**

Horseplay III, **Retina Print, 2004.**

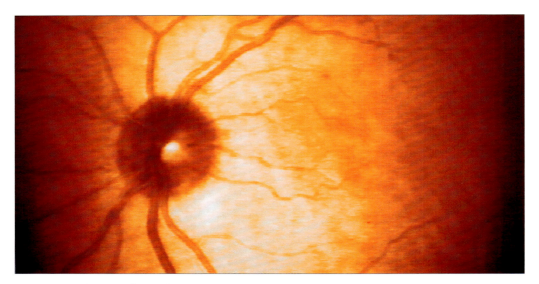

Glowing Retina, Retina Print, 2001.

VI

Poems from *Without Warning*

Aztec Moon

Electronic bees
surge.
I cower,
razored by information
grazing my temples.

Fly over Teotihuacán today.
You'll see it all –
knees inching up to the altar,
Jerusalem roosters,
yellow fever,
German measles,
med fly,
Montezuma.

Time's running out.
Hands fall off the clock.
Stop
the Age of Aquarius.
Stop
calling hate
disease.

Tall Buildings

Tall buildings
zip down their flies
zip up their flies

Tall buildings
leap inside glass elevators
going up

Tall buildings
stuck on twelve
going down

Souvenir
(November 11, 1989)

The Wall is a zone
Nothing moves
Protection
The Wall is Jericho
The Wall is lighted
by the full moon that floats across it
The shadow of a shadow
The Wall is stopped velocity
Too high to piss over

The Wall is a set of watch towers
The Wall is architecture
An accretion
An erection
Landfill

The Wall is a Trojan Horse
The Wall is the difference between Mercedes-Benz
and perestroika
The Wall is open to the sky
Perpendicular
A parameter
A lesson

The Wall is a rosary of lies
The Wall is the hem on a skirt of iniquities
The Wall is an outcry
The Wall is a pastiche
A political asterisk

A souvenir
Sold piecemeal

Charlotte Moorman Trilogy

1.

For Charlotte
(censored hero of The Opera Sextronique*)
Dying Hero in Your Fight with Cancer

You played your cello wired, topless,
under water,
coming out of Kosugi's blue bag.
You made ice cellos, chocolate cellos, human cellos,
bombs, T.V.s.
You played cello fish, cellos at Guadalcanal,
red crosses pinned to Joseph Beuys' felts.

When Otto Piene said he'd fly you from his helium flower,
you didn't believe your luck.
You, fastened to a grand bouquet of helium-filled,
polyethylene loops, 200 foot-long tubes bent in half.
You, a cello strumming, flying sculpture, a sky angel,
floating out across the Danube, "somewhere in Austria,"
going up to 300 feet,
maybe higher.

For the premiere of "Sky Kiss"
you wore your custom-padded parachute harness,
your green gown and white satin cape.
Otto checked the ropes himself.
He didn't want to lose you,
wouldn't let you disappear
like a Queen.

*by Nam June Paik

2.

Paper Cello

*following an earlier version read February 15, 1992
at the Charlotte Moorman Memorial,
Whitney Museum of American Art, New York*

A bald shopkeeper
in Karlsruhe
inched up the ladder.
Far out of reach,
behind the faded rainbows,
he found an angel
stringing the cello.

You said you liked it
and you set it out
with your what-nots.

You said you liked it and you set it out on the lighted, glassed-in what-not shelves that Frank built to house your collection of dolls—your passion for hearts and Arkansas diamonds, and all the kitsch you killed for up and down the boardwalk in Atlantic City. You loved to save and fondle these treasures, the way folks do.

You always remembered my birthday, the day before Valentine's Day, your favorite holiday. I've kept the presents you sent:

1 brass heart
1 cut glass heart
1 plastic heart filled with medium-size shells

1 marble heart tied with pink ribbons and filled with miniature shells
a pair of George and Barbara Bush slippers
1 porcelain heart frame
1 frosted heart candle
a cherry-scented candle decorated with cupids
a penis-shaped heart vase filled with 11 chiffon roses
The paper shadow of your cello, embedded with shamrocks, that you made in Italy, one year before you died

That night
I was crying with Frank on the phone.
You passed through in a swirl of gold and purple lingerie.
Frank said
your last words were,
"I want a banana."

3.

Sometimes He Just Wanted to Sit with a Beer and Watch the Game

One and a half years since Charlotte died
Frank's getting ready.
At first he was relieved
not to have to give her morphine
nine times a day,
not to have to watch Charlotte dying.
Then he began to find her notes
hidden among the heaps of stuff in their loft –
things even he could not have known,
although he never left except to run for
morphine.

When I called Frank on Monday, late,
he didn't tell me he would die.
He did say, if the auction went wrong
he'd jump off the roof.
It wasn't a joke the way he said it,
but he promised to call on Friday.

At Sotheby's in London
half of Charlotte's estate sold.
Not bad for bad times.
Frank's heart began to tear,
an aneurysm in his aorta.
The day after the auction it burst.

We said goodbye to Frank
and to our views on saints
at the open casket in Brooklyn –
to the body, not Frank's face,
not his eyes,
not his hands or shoulders.

Frank, long gone of course,
we said to be with Charlotte.

I hear his voice razz the wire
warm, reassuring.
His voice still hangs around,
promising to call.

Blue Haven
(Tobago, 1987)

You never leave me
except to draw a face
or watch a diving pelican.
It doesn't matter
how little I see.
Our steps curl with the waves
and flapping trees.

One cruise ship passes
close to shore.
One pod drops.
One hibiscus wilts.
One palm leaf
splits.

The Blue Haven,
closed,
abandoned,
sold.

We won't go there anymore.

Socks

Walking the treadmill
I watch the socks get in front of each other.
I'm mesmerized by their red color
and the idea that they're your socks.
I've worn them without asking you.
Even if you won't walk the treadmill
your socks have gotten mixed up with my feet.
They're our socks.
I grin despite the friction of treadmill
and walking feet.

The Ashford Motel

I wish your eyes
could still see mine
I wish you could
tell me what you feel
not what you know

I wish we would drive to Ashford

I wish this were
a phase
that you would
ask me questions

I wish
you didn't hate routine
I wish
I didn't hate routine
I wish
the plants would die

I can see
without seeing
I can hear
without hearing
I can come
without coming
but not the leaving

Farm Stories

1) October Fire

The red leaves won't lie down.
They tap at the windows,
flirt to get in.
Anger gleams in their nipples.
Cool stones rinse their eyes.
They are not shaved,
grin to come in,
beg to lie down
everywhere.

2) Clean Winter

I'm waiting for the silver fox.
Soon his blue voice will cloud the moonlight
and his breath will catch against the snow.

3) Spring Floods

Rain's pounding inside my head.
New rivers flow from my eye-holes and nostrils.
Turtles fork seawings out of the mud.
Their wet tweets announce
another quicksand savior.

4) The Farm Wife

Her lantern draws water.
He is far away,
far as green glitter.

Asparagus
stands loose in the field.

Gedächtniskirche

(Memorial Church in Berlin,
Rebuilt in the '50s)

I crave the blue
It chews me
Its teeth eat my heart out

Blue bones
Blue fire
Anger is blue
Blue chants
melt in blue coffee

Blue without breath
Blue without fire
Blue stamens bring a red poppy

Sunflowers

They smash
headlong
onto green earth
Yellow bonnets tangle
Faces bulge.

(Molly Bloom
caught ripe
too heavy
too full
too soon
falls off her stem.)

Upturned here and there
vague, sunny stares
go slack.

Dark glasses
from then on.

Yoyo

I don't believe in the prairie twister
slamming onto frozen ground.
I don't believe in seasons of croaking frogs
and dying moths.

I don't believe in omens,
witches,
the car crash that leaves one kid in a coma,
kills the other.

I'm falling
with nauseating speed.
Things miss;
have happened;
have not happened,
yet.

Will I toss and turn
under the paws of the she wolf,
forever?

I want to see a star
bloom from the heart of an oak.
I want to split palm fronds
and blow sirocco,
anytime.

I want my eyes back.

Post Op

Micro-surgeons have drained my eyes.
I look in the mirror
at the glasses on my face.
I don't see my face
but images outside the window
pour into the mirror
through my lenses:

 Dog jumping
 Sun on wheat
 Blue
 Van Gogh
 Sun
 Green
 White flash
 Black
 Bird
 Fly into light

Smiling string
Leaps into yellow pails
Crows red
Shoots black
Into
Yellow black
Revolver

Morning Glory
(paraphrase for Paul Éluard)

Two days after surgery
the doctor unwraps my eye.
Her pencil red lips
burst into Red Lips
Without Warning.
The sky out the window
fills with assassins,
trampolines.
Flashes of sight
jump between answers and questions.
Pictures steer my mind.
Sparklers.
Reason's a cloud
parodied by the moon.

Her pencil red lips
burst
Without Warning.

Stained Glass

I sit in the crypt of starry Sainte Chapelle.
The stars dim. They don't blink.

a jagged flash
light
crashes through
the painted
night

unplugged rods and cones
purple traffic
green river phosphenes
sand beaches

I blink.
Lights stay in droves –
adenoids to blackness,
misfirings,
misguided currents.

My brain is popping bleeps.

The Electronics of Blindness

Electric octave drops to blue tone.
My eyes are portable TVs.
My sight's a bloody vigil.
Magnetic fields grip bits of decomposing blood
like wasps sucking honey.

Eyes monitor isolation.
A man fastens his ladder to a truck.
Beyond the peptic green light
violet eagles rise,
tracked on both my eyes.

She Construction

Everybody loses a watch,
trips,
faints,
gets depressed.
I kick the crocheted doorstop lady
(with token eyes)
flat on her back,
slam the door.
I'm the parenthesis
(earth and moon),
the Maenad go-between
where waves rock.
Lasers etch my soul fish pink.

Would I rather be someone else?
Maybe, once, (Elizabeth).

I Need a Metaphor

My feet toughen
Toe ends yellow
I see what happens
Every word becomes a sign:
 Chairs stand for fortitude
 A table,
 horizontal boredom
 Travel,
 orgiastic pain
 Erasmus, maybe,
 the dead.
It's my toes that first expose memory –
 flooded skating rinks,
 frozen feet,
 hands stinging,
 skin on skin,
 tingling lips
 stuck to hot cider.
Our eyes stood still,
pressing sweet, incalculable cold
into souls we could not bare
enough to see.

Lunar Landing, **Retina Print, 2003.**

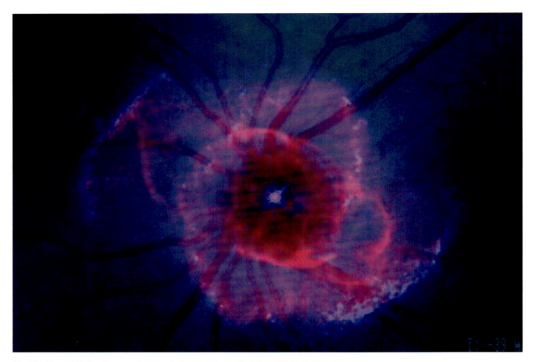
Cat's Eye Nebula on Ananda's Retina, Retina Print, 2003.

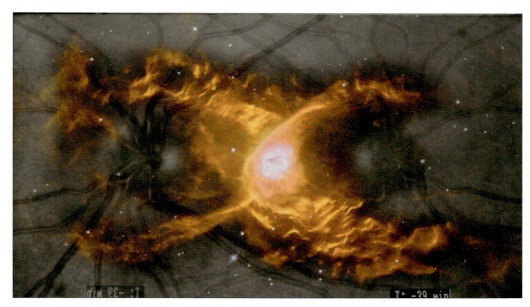

Twin-Eyed Galaxy, **Retina Print, 2004.**

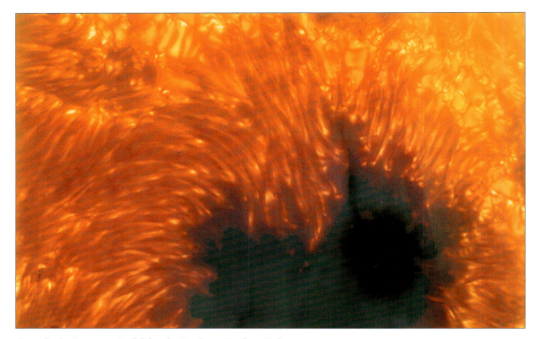
Goethe's Sun on Goldring's Retina, **Retina Print, 2003.**

VII

Poems from *eye: poems & retina prints*

On Returning to Taroudant

Everything's still sugared,
tea
orange juice
yogurt.
Our taxi driver speeds off
without giving us a receipt
because he can't write.
At the hotel
people lie around the pool
striking national poses.
The cat's back
clatter of plates
cooing doves
the way light meanders
through openings and shadows.

Le traité de soir,
black sky pinned with stars.

Four a.m. duets of morning cocks
and muezzin.

Lavender

Did Hegel say
r e d
is absolute?
No,
it's *lavande*
in Senanque
where the auras of all color
vibrate
deep as the throat of a mocking bird.

And oils
spill hot shine,
flow
purple.

A nun crosses the field,
her fluttering habit
a lunar bird.

Driving Down to Nice

I remember
the four a.m. flowers
the fresh scents
the closed air of the car,
how red sun
filled the blue morning
as we drove down to Nice,
and how s h e came up
over the knobbed hairy tit mountain
(the citron sorbet in Cassis
with lemon rind pressed in it)
the sun
burned black at the center,
orange
opening into yellow
(the taste of lemon rind).

As we drove into Nice
I felt the earth shake
and the bitter aftershocks
as shadows of the black sun
crossed your eyes
clouding the lavender fields
back at Senanque,
stifling songs of *missa solemnis*
still hot in my gut.

Dubrovnik, 1996

From the ramparts:
fresh blood of new roofs

centuries of torment
locked in stone.

 In Nebraska
 voices carried by clouds
 evaporated with clouds.
 Wheat held cries of strangulation
 only a moment
 before turning to wind.

On the prairie
pain was not immortal.

Wild Flowers

Daisies, dianthus
and phlox
outdo the planted perennials.
Stars
unframed in the wheatfields
wild,
unpainted.
Here and there a wizened carcass,
or a snake
looking like a stick in the grass.
I want to pick these fields for you,
bring them into the barn
where you are painting
blue women.

Going Home

I wonder if it's all still there:

pale lights of fireflies caught in jars

Dutch elm disease and the ringing of trees
up and down Rathbone Road

tornadoes and twisters
that took the roofs off houses
at the edge of town

headlights drowning in streets
flooded by Antelope Creek
just a block from our meat locker
and the house with Jesus Saves
painted all over the outside walls.

A high wire cage
fenced deer
and remaining bison
so we could feed them bread.

We passed the fall-out shelter
every day at noon
on our way to Van Dorn Drugs
and the in-ground trampoline.

After several of us got hurt
it was removed as a hazard
like they took away the x-ray machine downtown
where we could watch the bones of our toes
turn green inside new shoes.

At Miller and Paine's foundation shop
I got measured for my first brassiere
the summer
the asphalt sank
beneath my new spiked heels
(3 ½ inch red patents)
and we all saw
Pillow Talk and *Gidget Goes Hawaiian*.

During the polio epidemic
we stayed away from circuses, gutters,
county fairs and public swimming pools.
When Nancy came down with it
we tried to get her to walk again.

We pretended her wheelchair was our getaway car.

The Casket Shop*

The casket shop on Hüttenstrasse
once sold cheap flowers,
before that, maternity clothes.
It caters to a local clientele,
German, Greek and Portuguese.

Grain and carved wood coffins
laid out spaciously
suggest elbow room in the "upper room".
Store fluorescence shines so even
there's never an electric glitch,
no shadows.

A young couple
arms linked
walk between the boxes
as if they are cars.

A middle-aged man, hands clasped,
bows his head.
A pencil-nose woman with a Sistine smile,
perhaps she pictures her husband of 50 years
couched not in front of TV,
but in one of the beds
she would provide.

Lights up and down the street go off.
Lingering spots illuminate the cost.
You can get a basic box for just 200 DMark
or you can customize your casket
with photographs, poems, trinkets of life

*(a practice almost Egyptian).

Eros Ambulance Service

Role call
to all
crazy, sick,
dying.

Skidding through October fires
Eros burns rubber.
He chases naked light
onto naked windows

catches
women
in
free
fall.

Wrists white
fingers
reaching
Oh,
how we
bleed.

Harry

Old man
white thistle
sagging jowls
plays the Jacaranda
where he used to play
mainstage
trombone.

It's his birthday.

I say I can't see to dance.
He looks at me
like he won't believe.
Dancing me
into the waves

He said g o o d,
slid his trombone.

Til 3 a.m.
we danced.
Time to time
he b l e w o u t.

Next day
he sent me fifty roses
curled
with yellow
edges.

A Poet's Bath

Water
filling a sarcophagus
bathes
the poet.
Languishing
she idles,
purrs.
Eyes glaze.
Leopard lips bloom,
a sneer.
She scissors sentences apart,
trims vowels to rodent cries.
Her poems,
lost rosettas,
naked swimmers,
soap giraffes
without necks.

Trainspotting

Waiting's the essence of all feeling.

A train ride may be thirty-five minutes long
but anticipation can precede it by days.

It's still early.
I'm already at the station.

I wonder if she'll appear as she said in her phone call,
minutes after I expected the ring.

In last night's dream she failed to show up.
Trains horn the distance.

As I wait, in full view of platform and street
a man swings in on crutches.
I finger a wad of chewing gum under the bench.

Maybe she'll come by car.

(for Dan Jaffe)
He's
Reconstructing Dan
he said.

I always saw him
whole.
Wide hat
pushed back,
he's off to Florida
for good.
Eyes squinting
downturned at the corners,
casting about for
a new tune,
a fresh soul,
the next poem.

No Smoking Please
(for Daddy's 80th Birthday)

Where are your pipes?
chewed black
cherry bowls,
puffed clouds of smoke,
logo for your TV show
on the West.

You packed them away
so carefully
in that shoebox tied with string,
said you'd get them out again
once you retired.

Reason glowed in your hands.

You admonished me
for stripping birch bark off a tree.
Before it was politically correct,
you showed us the shame of Pine Ridge.

While you beheld Vesuvius
and Popocatépetl close up,
Chinese poppies, too,
I took off for Paris
fuming Gauloises.

So far,
no smoldering tobacco
escapes beneath your study door.
But you have yet to retire,
your final work
still in draft.

> *read at The Four Seasons Restaurant, New York City*
> *January 23, 1997*

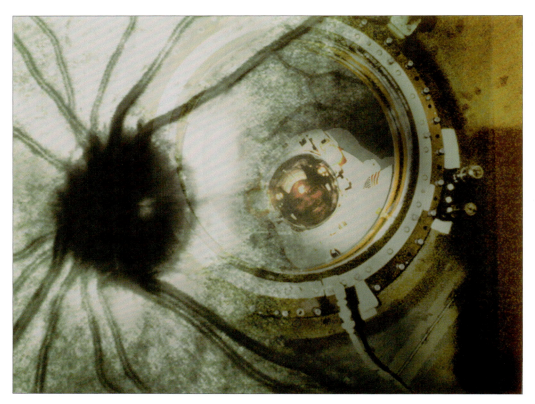

Eye to Eye (Astronaut), **Retina Print, 2003.**

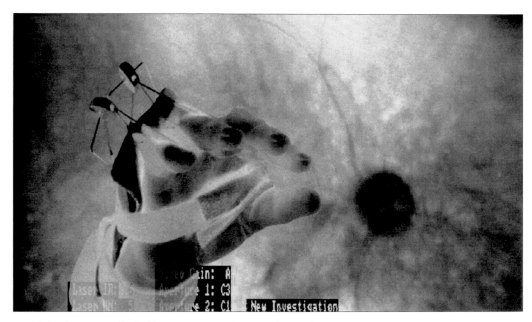

Goldring's Dynamic Splint on Her Retina, Retina Print, 2000.

Cavity, Retina Print, 2005.

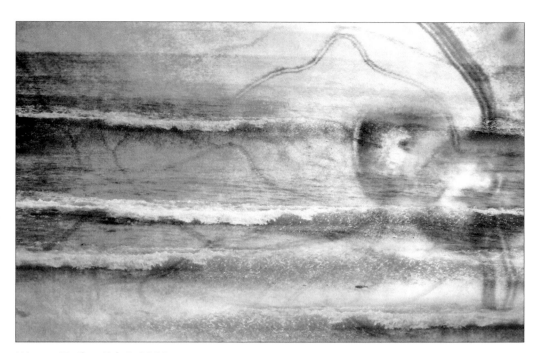

Waves, Retina Print, 2005.

VIII

The Light Silo/Das Licht Solo

Echoes of Fire

. . .

I will live one day
inside the eye of a fly
the heart of a flower
green gaskets of beetles
cadmium flies
heathers of peacock
spawning inside
hatched
(repast of the flower)

. . .

Petals unpeeling
in runways for bees
icicle tendrils
opalesque leaves
(like a bee sees)
wavily touch
outside the round hut

. . .

Diamonds are soft
diamonds are hard
pinching of stars
Empedocles' host
clafoutied with care
(a spiritually conscious
consummate house)
snail's smiling ghost

. . .

Horse, track and rider
are washed at noon

The season of forest
has nothing to hide
except conventions
riddled with pride
and solvent solutions

Echoes of echoes
caught in fire
cello to voice
voice to lyre
the rose of the source
(King Tut's corsage)
is pinned to our thighs

Is fragile/will not break

Roots are somewhere
-eyes-
glistening teeth
mouths of
slightly whispering flowers

You were forever
playing with fire
searing both
sides of words

P.S. until "once" came loose.

The March Bell

Hectic in ice,
frozen in rain,
only the ambulance gets through.

Snowberries quake
like tin soldiers in retreat.
Birds rehearse
songs
against drying sheets.

Inside the silo
a single note expands,
long as a train ride,
fresh as a glass of water,
circling the octagon
inside my head,
inside the silo.

The gong
presses down
from the heights of the tower.
In the folds
and creases of space
a chord,
a harp,
a palate of voices.

Angels?
No.

Outside,
the hegemony of spring mud
and morning rooster crows.

The Light Silo

We trucked in gravel,
installed new doors.
Rolls to sit on
were brought from the barn,
dusted off.

We polished the star
(a perforated Star of David
made for Yeshiva).
Using a winch we hoisted it up.

A star in low suspension,
a dark spot,
a mote in the oculus.

That night
the only sound,
the sound of acoustics:
our magnified breaths,
waiting for magic,
waiting
for the throw of the switch
to turn it on.

Faucet opens.
Light gushes forth
flooding the silo.
Projected ghosts
scamper the walls,
straddle oceans' air.
Ingots of stars

rain from our fingers,
reflections of reflection
spin without spinning
dissolving shoals,
shorelines,

until once again
the eye goes dark.

Cobwebs

A spider spits out webs
at the rate of one a day,
costs half a fly in energy
to build a web
this way.

Hungry spiders
cast a looser weave,
more economical, they say,
to catch their daily prey.

A spider without a web
is blind,
without threads
no vibrations will catch
the traipsing fly.

The Scarf Dancers

Why is it that people
who would lead me
grab
my arm
pulling me off center
until I am a circle
not a line,
a twisted circuit of
friends and helpers.
I would rather take an arm
walking straight ahead
with all the confidence
of being led.

For days
a gathering storm
puckered around the edges
getting ready to
spill,
to become uncontained,
unwinding
its scarves
to dance
through my eye.

Byzantium
was a gift of
sight beyond what
I had known.

As if I brought
the Istanbul dancers
home with me,

safe in my eye,
their faint shadows
move against the white walls,
over this sheet of paper.

It will be hard
this time.

The scarf dancers
appear again.
The dancing shadows
of their scarves
curve,
breathing
to their own
improvisation.

Antarctica

From Antarctica
my cousin wrote about the blue
of glaciers,
her father's eyes,

our family
eyes,
their dispassion,
the passion of inbred
madness,

in my eyes too
when Easter lands in March at the full moon
and the bobolink sings on the hoarfrost
after the clocks have been set ahead,

and sky,
blue as glaciers
in my genes.

Frog

Every day
I catch him,
throw him out.

Every day
he's back,
slothful,
hanging out.

Others
swim around him.
Their fast actions
parody his lazy
green smile.

As I do my morning laps
sometimes he swims along beside me.
With a flick of his loins
he mocks my strokes.
His legs splayed,
I throw him out.

Little romeos and juliets
chords vibrating
underwater
hide from the shadow of my net.
Their chorus swells.
A single tone attracts a mate
to play
until, chloroformed,
they die.

Aha,
The Grand Seigneur is back.

Ornithology

Birds imitate birds:

magpie songs sung by warblers
robinsongs by jays
peewees by grackles.

The birdbath is red.
Our cat is hunting.

whistling chickadees
warbling wrens
rasping finches
lonesome hens

barking cat
birds

It's the new millennium.

Owls grow quiet.

The Last Time

I speak to you for the last time,
hear your voice for the last time,
your eyes,
your hug,
your final kiss,
your morning breath,
my Listerine.

For the last time
you catch the 4 a.m. breeze,
a gentle whip-o-will.

For the last time
I took a plane across an ocean.
For the last time
I felt entirely myself – no masks.
Where will I find new masks?
How can I make them strong enough
to last without

your footfall,
the way you close the doors,
your geomancy that lets me know
exactly where you are?

Fiction will forever haunt the platitude
"See you later":
SEE, when I am mostly blind,
LATER, always potentially a lie,
YOU, slipping off already
into the last time.

In Berlin

In Berlin
a woman rides a bicycle in the pouring rain.
Holding a black umbrella
she talks on a cell phone.

The brick chimneys
silent now,
not
smoking ominous,
noxious fumes,
fumes that still burn the eyes
in air
still ladened with whispers
from bunkers
in ruins
expecting renovation,
reuse.

The chimneys are silent,
waiting
to burn,
burn,
burn.

The archeology of the city resides in museums.
From walkways without railings
we view the plunder
of gods,
agencies,
madmen.

The steeples of churches,
lanterns of power,
are darkly silent too.
They take their place beside the chimneys.
It's not their time.

In Berlin
a woman rides her bicycle
through rain.

Ceely (a.k.a. Maude)

The marshes open up.
Our beagle lies dying.
In her eyes
the look of far away.
She's being carried there,
knows it's her time,
begs to be petted,
wants to tell us she loves us.
She harks to the marshes,
wants to go with me
to our place by the river.
She won't make it that far.
She's dying.
The color
drains from her face and fur.
She eats only cat food.
She's so tired
she lies down in the middle of the road.
We choose her resting spot
next to the dead parakeets she never knew,
and Baer who was struck by an oil truck.
She lies in the road but the cars don't hit her.
She's led a charmed life
free as Houdini.
Her spirit readies itself
to prowl,
to stand guard,
to watch over her children.
Once she carried them
birthday cake on a plate.
They know their mother is dying.
Pepper's the saddest.
He howls at night,

begs her not to go.
In her eyes the marshes are frozen.
With the color of marshes in early spring
she dies.
Her days feigning a limp or an illness are over,
the dignified way she begged at the table,
always standing apart,
quietly imploring.
Maybe we'll go for a last walk,
the 6 of us together—
Ceely,
Pearly the cat,
the two puppies,
Otto and me.

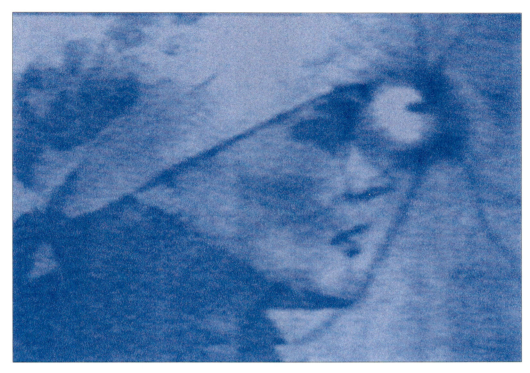
Eye to Eye (Elizabeth Goldring on Otto Piene's Retina), Retina Print, 1999.

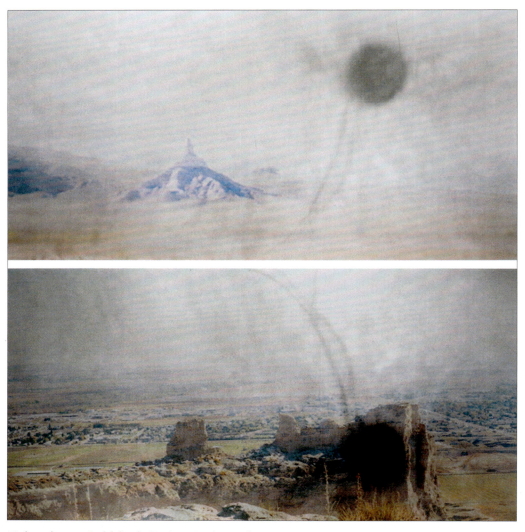

Nebraska on Goldring's Retina, **Retina Prints, 2001.**

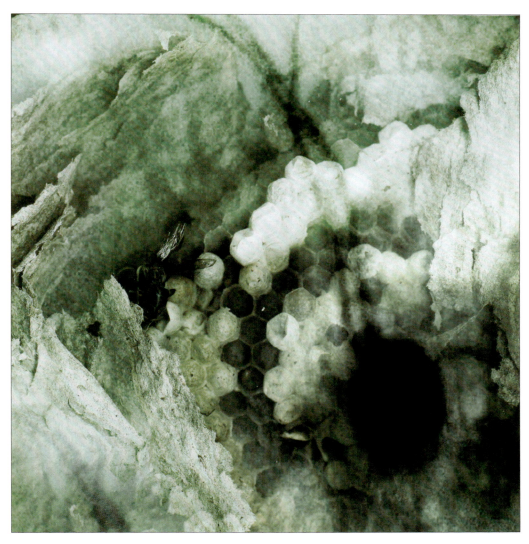

Hornet's Nest, **Retina Prints, 2002.**

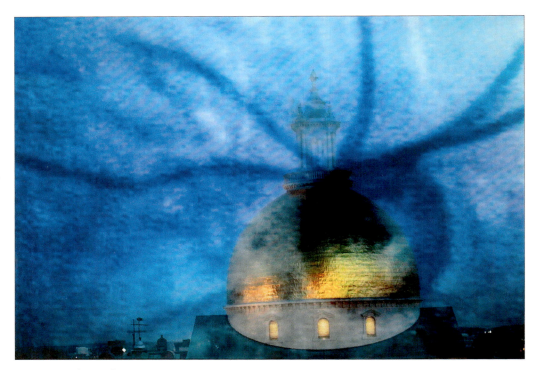

Dome, Retina Print, 2007.

Elizabeth Goldring Piene (née Olson) was born in Forest City, Iowa. She grew up in Lincoln, Nebraska and during her father's sabbatical years she lived with her family in Rome and Mexico City. She received her B.A. cum laude from Smith College and a master's degree from Harvard University. Although visually challenged, she continues to work as a poet, writer, media artist and inventor. At the Center for Advanced Visual Studies, Massachusetts Institute of Technology (1975-2013), she held positions as research fellow, senior fellow, acting co-director, exhibits and projects director, and lecturer. While at MIT, she invented seeing machines and created a visual language, retina prints and video documentation addressing conditions of blindness. Goldring has authored five books of poetry and *Centerbook: The Center for Advanced Visual Studies and the Evolution of Art, Science, Technology at MIT*, as well as several articles and exhibition catalogues. Her poems have appeared in several anthologies and journals including *Asylum, Prairie Schooner* and *New Letters*. She has given readings and performances in the United States and Europe. *Corona Diaries 1* and *2* were performed with flutist David Whiteside for Silo Solos at the online Frankfurt Book Fairs during the pandemic (2020, 2021). In 2004, she was awarded the Smith College Medal and in 2006, she received "Best and Brightest" awards from *MIT Technology Review, Esquire,* and *Scientific American*. She lives and works in Groton, Massachusetts. She also maintains a residence in Boston. Goldring was married to the artist Otto Piene, who died in Berlin in 2014. Her daughter, Jessica Spira-Goldring, lives with her family in Brittany.